Crusade For Your Audience

FINDING AND CULTIVATING ART COLLECTORS

Jennifer Yoffy Schwartz

Crusade Press
Atlanta, GA

Jennifer Yoffy Schwartz/Crusade Press
PO Box 8688
Atlanta, GA 31116
www.crusadeforart.org

Crusade For Your Audience/Jennifer Yoffy Schwartz. —1st ed.
ISBN 978-1-943948-06-2

Contents

CONCLUSION

ABOUT THE AUTHOR

So many artists say they're not aware of audience.
For me is unbelievable.

—MARINA ABRAMOVIC

Part One

In this first section, I retell the lively (and at times, harrowing) tale of my journey to find audiences and collectors for my gallery and the photographers I represented. There are many parallel lessons individual artists can take away. At the very least, you should be entertained.

How Hard Could It Be?

I n 2009, I opened an art gallery – almost by accident, certainly not after extended (or any) research or experience. I had an opportunity, and only two thoughts came into my head before I said yes: *How hard could it be?* and *That would be so fun!* I quickly learned the answer to the first was "very" and the response to the second was "um, sometimes..."

The first time I had what I now call the "Red Flag Thoughts" was in 1999. I was living in Boston, and a coworker told me about the Boston to New York AIDS ride. This was a 3-day, 250-mile bike ride between the two cities. Fun! Never mind that I did not yet own a bike, had hardly any athletic ability, and was not fond of sweating or generally exerting myself too much. Yeah. Super fun.

But that disaster ten years behind me, the gallery adventure seemed totally doable. (Besides, it seemed like physical exertion would be minimal.) I was a photographer and a very new fine art photography collector, so opening a gallery with a

photography focus seemed to make the most sense (as opposed to other mediums, about which I had even less knowledge). So I decided to exhibit and sell the work of emerging photographers, because Atlanta already had a wonderful and prestigious blue chip photography gallery.

Emerging photographers are those who are just starting to make names for themselves and most likely have very few existing collectors. Because they are at the beginning of their careers, they do not have a sales track record in the secondary market to validate their pricing structure, and there are no guarantees that their work will increase in value or even hold their value.

On the flip side, the work is less expensive than that of more well-known artists, and photography is typically priced lower than other art mediums. The affordability of my product was an asset.

Affordability is a great advantage. What were my other ones?

Fine art photography is gaining a more prominent foothold in museums and other art institutions. Also, photography is very accessible. More people are taking pictures on their own, which is creating a greater appreciation of the medium – how it is done and what it can do. It is also diverse. Photographs capture the real world, and through Photoshop and other manipulations, it can also create new worlds. Photography is a medium that has incredibly broad appeal to a growing chorus of fans.

I had some personal advantages as well. Some may view having never worked in a gallery or tried to get my own artworks in a gallery as a giant obstacle or impediment. True, this presented a giant learning curve to climb (and I thought

there would be no exercise!). But I saw this as a benefit, for it gave me the freedom to try new things. I did not have any preconceived idea of what was or was not acceptable gallery practice. Many emerging artists eschew tradition and seek to push the boundaries on existing practices. It only made sense that the gallery I sought to create to represent them would follow suit. The goal was to get exposure and collectors for my artists – by any (legal and ethical) means necessary. I'm creative, passionate, and I'm scrappy.

It became obvious that if I needed new ways to market unknown artists to potential collectors, I was going to need to rely heavily on creative marketing. There is a misconception that artists simply need to create incredible works of art and the adoring public will come out of the woodwork with checks in hand. Not so, unfortunately.

Another advantage is my prior experience with and love of marketing and creative branding. I think about how people think, and I love to figure out how to create a connection. I have an undergraduate degree in psychology and a master's degree in counseling, and although some may say I did not utilize those degrees, I would believe I have used them to exhaustion. (You may not know this, but sometimes artists and potential collectors can be. . . well, a handful.)

Creative branding is not new to me. I started a portrait photography business in 2000, and even more than the families and the shooting, I loved building the business. I wanted to focus on babies and children, but since I had neither at the time, I needed to find some kids to photograph in order to create a portfolio and website. I had a couple of nieces and a few close friends with babies, but I knew I would already have

their business once I started rolling. So instead of borrowing their kids for an afternoon, I took a different approach.

First, I thought about who my ideal client would be. A person with kids, obviously. But beyond a parent, I needed someone who valued unique, artistic photographs, and that person had to be willing to pay a premium for them. My ideal client would most likely seek out clothes and accessories that were less common and more expensive than what they could find at Target or Old Navy. Their birth announcements were custom-made. Their birthday parties were over the top.

I made a list of my friends and acquaintances who fit my ideal client mold. Then I selected five who were in different social circles from each other and approached them with an offer: a free photoshoot in exchange for referrals to their friends. Not only was I building a portfolio of images, I was creating ambassadors. (You may want to note that last part. It will come around again.)

Fast-forward ten years. Ambassadors bred ambassadors, and I had a booming portrait photography business. I decided to lease commercial space where I could meet with clients and shoot studio sessions. Looking around the city with a broker, it seemed that all the commercial spaces that were suitable for my studio were larger than I needed. After a lot of looking, I found a space that was located in a convenient part of town and had ample parking. It also had about 800 square feet more space than I could use for a studio.

Lightening strikes - an idea! I could use the extra square footage in the front of the space and open an art gallery. BAM! (Wait for it. . .) *That would be so fun!* Sure, I did not know much about galleries, but *how hard could it be?* (DANGER: Red Flag Thoughts)

Oh, to own an art gallery. Such a glamorous life, filled with cocktail parties and cool clothes (the black turtleneck not withstanding). Surrounded by beautiful people having fascinating conversations. Looking chic all the time and saying "fabulous" a lot. *That would be so fun!*

Owning an art gallery was almost like that. There were cocktail parties, but I was buying the alcohol. The cool clothes did not magically appear. There were beautiful people and fascinating conversations . . . spaced out about once every six weeks. I spent a lot of time hanging shows in yoga pants (wait, am I sweating??) and saying f*ck a lot.

The Magic Formula

How hard could it be?

I had been to galleries and art openings. As far as I could tell, most galleries were operating off a single basic premise – a magic formula, if you will.

ART + CHARDONNAY = SUCCESS

Not every gallery employed the magic formula in the exact same way. Some added snacks. In my short observation period, I had experienced snacks ranging from paté to Easy Cheese (I noted that both required crackers). Also, wine quality could vary significantly. Sometimes there were even wine choices, and a particularly edgy gallery I once went to offered craft beer on tap.

There were other details I picked up – walls should be white, lighting should be good, vinyl show lettering looked tricky. Basically, all I needed was the magic formula, a gallon

of paint and a YouTube video or two, and I would be totally prepared. *How hard could it be?*

I nailed the prep work. The frames were straight, the mats were extra thick, the vinyl lettering was air bubble-free. The gallery was beautiful. I took a proud look around the gallery on opening night and gave myself a pat on the back. Watch out world.

I took a deep breath, opened the doors, and . . . where was everyone?

Apparently I missed a step (or dozen) in implementing the magic formula and all of its accouterments. I spent so much time making sure everything looked just right that I didn't put much thought into getting people in the door. An email went out. I posted something cheery on Facebook. But damn, that vinyl lettering looked hot.

Artists share a similar experience. We are makers. We create. Correction: We think and agonize and obsess and think some more, and if we can get out of our heads for any significant amount of time, we create. We spend so much time and effort on the art-making process (as we should), but we do not give much (if any) thought to what to do with the work after we've made it. We make magic, we throw up our hands with a flourish (ta da!), and . . . where is everyone?

We are all in this together, and the more creative energy we can amass to put toward cultivating audiences (and collectors) for art, the better.

Getting It Done

It's not that no one showed up to my early openings. It was just that the people who were coming were not the ones I wanted. The gallery was full of artists who were there hoping to get their own work on the walls. We also had the steady stream of older, camera-wielding gentlemen who troll for free wine. Neither of these groups was buying art.

After a few of these fun but expensive, chardonnay-draining events, I decided to make some changes. The magic formula had let me down, but I refused to be defeated. First, I would switch to pinot grigio. But I would also spend some serious hours thinking, reading and researching to answer these critical questions:

Who was my target audience?

What connection points did I have to these target people already?

What obstacles did I need to get around to reach them?

Target Audience

The people coming to my early gallery events were not my target audience, so who was? As I mentioned earlier, I was showing the work of emerging photographers. The work was affordable, especially compared to other mediums and compared to more well-established artists within the medium. Photography is also accessible – we understand how it is done, and so the intimidation a person may feel around art is usually less intense with photography.

Targeting established photography collectors did not seem to make a lot of sense, because they most likely already had relationships with galleries and gallerists they trusted, and because people who buy blue chip work do not typically collect work from unknown artists (at least, not significantly). Given the price point and medium, I felt my target audience were those who were positioned to begin collecting art, they just hadn't realized it yet. Fresh meat.

I imagined my ideal future collector and gallery patron to be a young-ish (30's and 40's with a wide margin on either side), well-educated, professional person who was engaged in events and organizations in the city. This person had some disposable income that they often spent on trips and trendy restaurants. This person did not mind spending $5-10 per day on a latte at the hipster coffee shop, and he or she regularly sought out cool and interesting events and experiences.

While challenging (how do you find people who aren't looking for you?), this also seemed like an advantage. The number of people who live in Atlanta who collect blue chip photography is relatively small. The number of people who

live in Atlanta who can afford to and may be interested in (if introduced in the right way) collecting lower priced, original art is significantly higher.

Connection Points

You may remember that when I began my portrait photography business, I made a list of my friends and acquaintances and identified those who fit my ideal client mold. Then I selected five who were in different social circles from each other and approached them about my new business. Time to break out the pen and paper.

Who did I already know who fit my idea of the target gallery patron? While I had a lot of friends who thought it was cool to come to my gallery openings every once in a while to give me a fist bump and pre-game with a glass of chardonnay on their way to dinner, most of them did not buy art, nor would they. And the friends who did buy art were already on my team. I needed to widen the circle.

There was a woman in my yoga class – a single lawyer who was funky and stylish and went to (and often helped plan) a lot of the most interesting benefits and events in the city. Time to start grabbing coffee after class. I thought through my photography clients, friends of friends, parents of my kids' friends, my dentist – anyone who had ever perked up a little when I told them what I did for a living and seemed like they could be swayed to the art side.

These people became my ambassadors. They bought into the idea that they should own original art and that the gallery was a fantastic place to buy it. They came to openings and events and brought friends, whom I then also got to know.

Ambassadors bred ambassadors, and pretty soon things started to look a lot like success.

Obstacles

During this ambassador-building phase, I began to read research and studies about arts engagement. I was curious to learn what was preventing people from connecting with (and buying) art and what could be done about it. I was also talking to a lot of people I knew about their level of interest in art and how that compared to their level of involvement with it. There are plenty of people who have no interest, and that is its own mountain to climb, but I was looking for people who had an interest but had not explored it. If the interest was there, what was holding them back?

What I read in the studies was very much in line with what I was hearing through my own anecdotal research. People perceive barriers to entry when it comes to participation with and enjoyment of art.

Some of these barriers are just a matter of having false information. For example, many people feel that art hanging on a gallery wall will be out of their price range. This is not necessarily true, as my gallery (and plenty of others) sold work at all different price points, many of them very low. Plenty of pieces I offered for sale cost the same as a night out and a new pair of jeans. My target audience was not balking at paying for outings and clothing – art just wasn't a line item in their budgets. I love good food and designer jeans, and I also love art. And if I had to choose between the two (which I hope never to have to do), art makes me feel something every time I pass the piece on my wall for as long as I like. Jeans don't always feel so great, especially after a big night out.

In many cases, people do not feel they know enough about art to properly enjoy it, much less buy it. At a very basic level, no one likes to feel stupid or embarrassed. Even I have a hovering fear of getting approached at a gallery and being asked what I think of the art. What if I don't get it? What if I don't have anything interesting or intelligent to say? Or worse, what if I say something so off-base that I sound like a fool?

Resolution

I knew I could not give everyone that walked in the gallery door a degree in art history, but degrees were not needed. The intimidation does not come from a lack of education so much as from a lack of confidence. So maybe the solution was to disguise the art experience. Instead of offering a sterile art-viewing for art-viewing's sake atmosphere, I could create fun, engaging experiences with an art bomb inside.

The studies I was reading echoed this idea (but in much more sophisticated terms). The Wallace Foundation's report, Cultivating Demand for the Arts: Arts Learning, Arts Engagement, and State Arts Policy states that "an aesthetic experience – one that actively involves the spectator's senses, emotions and intellect – is crucial to engaging someone with art". In other words, I was going to draw people in through an interest they already had and felt good about and then throw an art bomb at them.

Art Bombs

I decided that all of this new, sneaky-genius programming would need to have three qualities to be successful: innovation, engagement, and accessibility. It also wouldn't hurt to sprinkle on a little edgy coolness and fun.

Fortunately, I'm an idea person. That may be an understatement. I breathe ideas. Inside my head is a scary place to be, and if a big idea comes, you best jump on board or jump out of the way, because it's going to come at you like a steam engine. The gallery had always been a little unconventional, and I was upfront with my artists from the beginning. However, this disclosure didn't prevent them from being nervous every time I called with an idea.

Walk Away With Art

Walk Away With Art (or WAWA as we affectionately called it) was one of those big ones. In thinking about how to encourage people to engage with art and become collectors, I wanted to develop a few "branded" events at the gallery to

work toward this goal. We tried several different ideas, most to great fanfare. But WAWA was the idea bomb.

The invitation read:

> 50 guests. 50 original, signed photographs.
> Everyone walks away with art.
>
> Fusing the element of chance with personal taste,
> guests draw numbers to determine the order they
> get to choose a photograph.
>
> Meet the photographers, learn what you love,
> party your ass off.

I invited seven of my photographers to give seven different images (one gave eight, making 50 total unique images) to pin up around the gallery. We printed the images for the photographers in a size slightly larger than 11x14, and each photograph was signed by the artist. I was also careful to select photographers who were aesthetically very different from each other, anticipating that invited guests would be drawn to different styles.

We sold 50 tickets, and every ticketholder drew a number from 1 to 50 when they checked in. All of the participating photographers were at the event, and each had a few minutes to talk about their work. Once the guests had enough time to look around and decide which pieces were their favorites, we started calling numbers. We went in order from 1 to 50, and when we called a number, the person with that number went

up to their favorite piece, took it off the wall, and became a collector. Everyone walks away with art!

An event like this works to build collecting on a lot of levels. At the most basic, it is an exciting and fun party. Great food, great cocktails, great art. People are coming into the gallery and having a really positive experience, making them more likely to attend future events.

Next, they are engaging with art in a meaningful way. Because everyone gets to take home a piece (original, signed), they are looking at all of the photographs and figuring out what they are drawn to. I purposefully chose seven photographers with very different aesthetics to showcase a wide range of photographic style and subject matter. Guests are now thinking about what kind of art they want to have on their wall and with so many options, they can start to look and reflect on what they dislike, like, or maybe even have to own.

Finally, they are having a unique opportunity to hear the artist speak about the work and meet them individually. Even if someone is not particularly drawn to a certain artist's work, hearing the photographer speak about it will still give a deeper appreciation and understanding. The opportunity to hear an artist passionately talk about their project and then make a personal connection to him or her is priceless and adds another level of connection to the photograph.

People were blown away by the photography, the concept, and the photographers themselves. While eating sushi and drinking the Westside Fizz, guests were milling about and getting a sense of their favorite photographs. Then after the photographers spoke, people wanted to have a few more minutes to take another look, and many people completely

changed their minds after hearing the stories behind the images.

Calling out the numbers was exciting, and sometimes when a piece was chosen, you could hear an "oh no!" There were a few occasions where tackling another guest was proposed, but civility was maintained (after all, these images are part of these photographers regular collections and very much for sale). Even though there were definitely some "favorite" images in the room, most people were drawn to very different work, so even people with higher numbers (meaning they were near the end to choose) ended up selecting one of their top choices.

After the selection process, most guests stayed and spoke to the photographer whose piece they ended up with, and the gallery was buzzing. People were excited, inspired – they were collectors, and they were loving it.

ArtFeast

As I mentioned previously, I had given a lot of thought to the type of person I was trying to lure into the gallery and introduce to art. I felt my target collector was a well-educated, professional who was drawn to new and interesting experiences. Like a lot of cities, Atlanta is full foodies with a lot of great, trendy restaurants to choose from. With the logic that someone who spent time and money at the newest and best restaurants in the city may also spend time and money at an art gallery, ArtFeast was born. I also happened to have a full kitchen in the gallery that seemed a shame to waste.

ArtFeast pairs the artist on exhibition and a noted chef/sommelier to collaborate on a wine-paired menu in-

spired by the works in the show. Ten invited guests, plus the featured artist and I, enjoy a seated dinner in the gallery. A delicious meal, surrounded by art, with the artist as a dinner guest – it makes for a lovely night and a truly unique experience where people get introduced to art in an unintimidating and accessible way.

AN IMPORTANT NOTE:

For each of these events, Walk Away With Art and ArtFeast, guests were invited to participate. The main goal was to introduce the gallery and its photography to new people we sought to become gallery patrons and collectors. If we had sent email blasts and Facebook invites to our standard lists, these events would have been populated with people who were already gallery regulars.

Time to call up the ambassadors.

This was a great opportunity to reach out to those people who fit our target audience whom we had already built relationships with and who had started to attend events and buy art. Taking some time to meet for coffee or have a phone call to explain the super awesome can't-be-missed upcoming event with limited space paid off in spades. Singling them out to let them extend invites to their friends not only served our purpose of reaching new people but also made them feel special and important to the gallery.

Art Circles and Collector Hosts

Your existing supporters are incredibly valuable. They are the ones who can help you strategically grow your audience. Let them know they are important to you and your success, and let them know how they can help even more. They are

unlikely to proactively help you grow your business, but I was pleasantly surprised by how much they were willing to assist when called upon.

Like clockwork, someone whom I had brought over to the art side would inevitably say, "It has been so fun getting involved with the gallery and becoming more comfortable with/beginning to buy art. I have so many friends who I think would be into this too." At this point I would suggest setting up an Art Circle.

An Art Circle is like book club without the homework. This gallery fan and I would co-host an informal gathering after hours at the gallery. We would have wine and snacks and a really casual discussion about the art on the walls and our experiences with art. This was a great opportunity to connect to people who were already pre-disposed to be interested in what was happening at the gallery (they would have declined the invitation if they weren't). It was a casual environment where people could feel comfortable asking questions and getting to know me. It was an easy introduction to people I could start building relationships with, in the hopes of creating my next set of ambassadors. (Also, it was fun.)

Playing on a similar assumption that people who liked what we were doing would also have friends who would like what we were doing, I also began approaching collectors about hosting a tea or cocktail event in their homes in honor of the artist whose work they had purchased. Typically this event would be planned around an artist coming into town. We would set up some easels with a few additional framed pieces in the collector's home, and the artist would have the opportunity to say a few words about the work and meet a new set of potential collectors.

People are often hesitant to ask for favors. We don't want to put someone in an uncomfortable situation, and we especially do not want to be on the receiving end of an awkward decline. But I never had anyone turn down one of these opportunities to host an Art Circle or an artist reception. Most people are thrilled to be asked and to have the chance to say to their friends, "One of my favorite artists is coming to town, and I am hosting a reception for her!"

Themed Openings and Pop-Up Exhibitions

The audience for the gallery began to build, and our events were creating opportunities to meet and begin relationships with even more people who would turn into new ambassadors. But just like anything else, it was important not to get lazy and let the connections to my first wave of ambassadors weaken.

On one occasion, I was circling back with someone who had been a regular at the gallery for a while. She said to me, "I'm sorry I didn't make it to the last opening, but I'll just come to the next one." This was a strange thing to hear, because "the next one" would be different art. She did not say, "I'm sorry I didn't make it to the last opening, the work of that artist just doesn't appeal to me." That would have made sense. But the way she phrased it, it was as if openings were just interchangeable cocktail parties.

Over time, I heard similar sentiments from a few different people and knew I needed to mix up the dynamic. It was not enough to create an aesthetic experience to engage new people with the gallery – I had to keep them engaged. (Owning a gal-

lery – how hard could it be?!) I decided to introduce elements into the openings that would make them can't-miss experiences, sometimes even changing the venue by creating pop-up exhibitions in unique spaces that complemented the work being shown.

For gallery openings, I began to do things that would make each opening feel unique. Signature cocktails. A photobooth with props or a background relating to the work on the walls. I was open to anything that would elevate the experience and tie into the art in a fun way. On the half-dozen or so occasions when we did one-night only shows off-site, we were able to effectively create a sense of urgency to attend.

A photographer named Michael Schmelling created a body of work that was turned into a monograph called Atlanta: Hip Hop and the South. We invited him to come back to Atlanta for a one-night only exhibition of the project, installed in a hip hop club, complete with a DJ and break dancers.

A photographer I represented, Heidi Lender, had a few fun, quirky projects and a large network of friends and family in New York City who had never seen an exhibition of her work. We created a pop-up exhibition at a retro barbershop in the West Village. Countless people said, "An art show in a barber shop? I just had to come see it." Exactly!

CHAPTER FOUR

That Would Be So Fun!

The art bombs were exploding with great success. The gallery was buzzing, collectors were budding, and people were genuinely engaging with art in really positive ways. It was the Camelot era for Jennifer Schwartz Gallery.

But wouldn't you rather trade gratification and accomplishment for challenge and strife? I mean, who wants to bask in the satisfaction of a goal achieved when you could set your sights on a project that would be nearly impossible to complete? Exactly, that's what I thought.

The programs we were doing at the gallery were working to attract new people to our openings and, in many cases, turning those people into new art collectors. But in all of these cases, we were getting people to come to us. What about people who didn't even have art on their radar? How could we reach them? How could we find these people and give them an art experience that would hopefully be transformative and make them realize that art could have a place in their lives

Crusade for Collecting Tour

I was pondering these questions with a good friend of mine, who is known to have ideas nearly as grandiose as my own. No one should let us hang out – nothing logical or considered can possibly come of it. However, hang out and brainstorm we did, and by the end of our extended coffee, a glorious (and very aggressive) idea was born!

He told me a story about how a denim magnate started his career by selling jeans out of the back of his car. What if I traveled around the country selling art out of the back of my Volvo? An interesting idea for sure, but Volvos are so dependable. Where's the challenge in that? What if instead of a dependable vehicle, I drove around the country in a 1970s VW bus? And instead of selling art, I could give it away. Enter, the Crusade for Collecting Tour.

This was the final time (so far) I would have both Red Flag Thoughts and not call in reinforcements to anchor me down and talk some sense into me. How hard could it be? (To drive the least reliable vehicle on the planet around the country with no mechanical knowledge, not to mention fundraise for a year and a half to do it. . . really hard, as it turns out) That would be so fun!

The concept was simple(ish) – travel to ten cities in a VW bus full of art and possibility. Curate five local photographers in each city to participate. The five photographers would meet me at a high foot-traffic street corner with ten copies of an image they were willing to give away. As people were walking by, we would call out to them and tell them that five artists from their city were giving away photographs. The passersby could meet the photographers, ask questions, hear the stories

behind the images, and keep the photograph they felt most connected to. The goal was to simulate a mini collecting experience. Participants would get to see a variety of images, learn about each one, and realize that they felt more strongly about one than another.

These spontaneous pop-up events to give away original, signed photographs aimed to bring grassroots art appreciation to the streets, moving outside the traditional boundaries of the art world. I felt that if I could give people a fun, disarming arts experience in an unexpected way—an opportunity to meet artists, learn about their work and connect to an original piece that became theirs—it could be transformative and put them on a path to loving, supporting and collecting original art. Seriously, what could be more fun than walking by a turquoise 1977 VW bus with artists giving away their own original signed photographs to anyone who wanted to have a chat about their image?

As it turns out, it is really difficult to give away something for free. In each city (Los Angeles, San Francisco, Portland, Seattle, Chicago, Cleveland, Brooklyn, and Washington, D.C.—Atlanta and New Orleans happened in late 2012 as "test" cities), we gave away 50 small (between 6 x 9" and 8.5 x 11") signed copies of an image over the course of the pop-up, which usually lasted about two hours. Saying things like "we are five local artists here to encourage art collecting in our city" and "become an art collector today for free," garnered both high-fives and the hand.

No matter the city, the quality of interactions between the artists and the people who stopped to participate was consistent. Most people wanted to see each of the five images, listen to the story of the photograph from each photographer,

and make a thoughtful, informed selection. The artists and I both received great feedback in person and through follow-ups from people who really connected. There were hugs and amazing moments on the street, and also emails, phone calls, and photos of the newly framed pieces hanging on the new collectors' walls. These were powerful and eye-opening moments for everyone involved.

The best example of witnessing an "aha" moment happened at the last pop-up event in Washington, D.C. A young woman was talking to us after selecting Hannele Lahti's photograph. She said this was her first piece of art to own, and when I asked her why she selected that image over the others, she said it was Hannele's description of what the image was about that really moved her. When she heard Hannele describe the photograph, she realized this art was about an experience she was having at that exact time in her own life.

In city after city, the same lesson emerged: People value connection. A lot of established collectors buy art because of the artist's reputation or the proven value of the piece—the art world as we know it is driven by trends and price tags, not experiences. But the status quo is not cultivating new audiences for art. To attract people who are not already connected to art, we need to provide opportunities to facilitate a personal connection between the artist, the collector, and the image. The tour was one of those opportunities, and for that, I do believe it was successful.

The New Magic Formula

As it turned out, chardonnay was not essential in the success formula. The key is connection. Art cannot live in a vacu-

um. Art needs people to appreciate it. To appreciate art, people need to feel like it has some relevance to them and their lives.

ART + CONNECTION = SUCCESS

Connecting The Dots

hat do my crazy series of adventures and leaps of faith have to do with the individual artist? Well, if nothing else, they should serve as cautionary tales. (As in: do not purchase a VW bus for reliable transport, do not open a gallery with no prior gallery knowledge, do not declare to the world that you are going to do something without first determining how many years off your life it will take you to get it done.)

As I said before, when I first opened the gallery, I was so focused on making sure everything looked just right on the walls that I didn't spend enough time thinking about getting people in the door. Artists have a similar experience where they focus almost exclusively on creating the work. They do not spend much (if any) time thinking about what to do with the work after they've made it.

While most artists dream a gallery will magically pluck them out of obscurity and turn them into superstars, the reality is often dramatically different. I had two options in my gallery: to wait for the people to come or to go get them. Artists

have the same options. It's easier to wait, but that is rarely an effective strategy.

Spend some time and think carefully about how to answer these questions.

Who is your work most likely to appeal to?

Who do you know who fits this description?
**

What connection points do you already have to this person?

What obstacles do you have to get around to reach your target collector?

Who are your ambassadors?

Now go get it done.

Part Two

There are many photographers who are smart and strategic about finding their audiences and building their collector bases. Their stories are inspiring and instructive, and this section is filled with them.

Jess Dugan

ess T. Dugan is an artist whose work explores issues of gender, sexuality, identity, and community. Dugan holds an MFA in Photography from Columbia College Chicago, a Master of Liberal Arts in Museum Studies from Harvard University, and a BFA in Photography from the Massachusetts College of Art and Design.

Dugan's work has been exhibited internationally at the Smithsonian National Portrait Gallery, the San Diego Museum of Art, the Cornell Fine Arts Museum at Rollins College, the Catherine Edelman Gallery, the Grey House Gallery in Krakow, Poland, the Griffin Museum of Photography, Gallery Kayafas, Carroll and Sons Gallery, the Leslie/Lohman Museum of Gay and Lesbian Art, and at many colleges and universities nationwide.

Dugan's photographs have been featured in the New York Times, CNN, The Advocate, Slate, The Huffington Post, and the Boston Globe.

Her photographs are in the permanent collections of the Museum of Fine Arts, Boston, the Museum of Fine Arts, Houston, the Harvard Art Museums, the Birmingham Museum of Art, the Grand Rapids Art Museum, the Cornell Fine Arts Museum and the Alfond Collection at Rollins College, the DePaul Art Museum, Fidelity Investments, JP Morgan Chase, and the Kinsey Institute for Research in Sex, Gender, and Reproduction. Her work is also included in the Midwest Photographer's Project at the Museum of Contemporary Photography in Chicago, IL.

Dugan's monograph, *Every Breath We Drew*, was published in 2015 by Daylight Books and coincided with an exhibition at the Cornell Fine Arts Museum. Dugan is the recipient of a Pollock-Krasner Foundation Grant and was selected by the White House as a 2015 Champion of Change. In 2015, Dugan founded the Strange Fire Artist Collective to highlight work made by women, people of color, and LGBTQ artists.

Jess is represented by the Catherine Edelman Gallery in Chicago, IL.

Your career has had a strong and consistent forward trajectory. How much of that do you ascribe to hard work and planning (vs. talent, luck, subject matter or other things)?

Over the past ten years, I have been working to build a career as an artist. Your question makes me think of the saying, "the harder you work, the luckier you get." I have always been very committed to my work and have maintained a disciplined studio practice, though the specifics of what that looks like have changed as my work has evolved. Even while pursuing my BFA at MassArt, I often skipped parties and other social engagements to spend time working in the darkroom. After

graduating, I built a somewhat shoddy darkroom in my small, 1-bedroom basement apartment and dedicated every weekend to photographing or printing.

I was fortunate to begin working with a gallery the year after I finished my BFA, and that experience was hugely important to my career. I began having exhibitions and learning about the art market at a relatively young age. The owner of the gallery also acted as a mentor on some level, offering feedback on new projects as well as practical advice about things like editioning, print sizes, etc.

I was also fortunate to somewhat fall into a career in the museum world. When I was about to graduate from MassArt (in 2007), my friend was leaving his part time position working in the print study room at the Harvard Art Museum and asked if I'd be interested in the job. I was, and that first summer out of MassArt I worked there 20 hours a week. The rest of the time, I was an intern at the Bernard Toale Gallery in Boston, where I worked closely with Joseph Carroll, who now runs Carroll and Sons Gallery. Both of these experiences were very formative to me as a young artist. The museum job allowed me to spend time with original works of art at a very intimate distance, and the gallery internship introduced me to the ins and outs of the commercial gallery market. It was also because of this internship that I met Arlette Kayafas, whose gallery I would be represented by for the first eight years of my exhibiting career. In the fall of 2007, I was hired full-time in the collections management department at the Harvard Art Museum, where my primary responsibility was photographing works in the collection for the database. I spent 8 hours a day looking at art and was also introduced to the inner workings of a museum.

Between 2007 and 2011, I worked full time at Harvard and pursued my work in the evenings and on weekends. Because of my job, I was able to take evening classes at Harvard for free (or $40 each, I think, instead of $2,000), so I also got a Master of Liberal Arts in Museum Studies in 2010.

My career was beginning to be successful, but I always knew I wanted to pursue my MFA, and I was also noticing that the grants, shows, and residencies I wanted were being awarded primarily to people with MFAs. For better or worse, I felt I needed one, and I also wanted the dedicated time to focus on my work. I heavily researched graduate programs around the country and decided to apply only to Columbia College Chicago. I was drawn to Columbia by the faculty - primarily Dawoud Bey and Kelli Connell, both of whom were my mentors throughout graduate school - as well as by their generous scholarship assistance and the opportunity to continue my career in the museum world by working at the Museum of Contemporary Photography, which I did for three years. Again, working at the museum was incredibly influential to me, as it exposed me to another unique set of original works and enabled me to meet a lot of people I otherwise would not have. I did a bit of everything at the museum - installed exhibitions, taught classes from works in the collection, assisted the curators with research and book proposals - but one of the most influential was organizing the monthly portfolio reviews. It was my job to organize all of the incoming submissions into a concise presentation and then present those to the curatorial staff. By participating in this process, I gained a lot of insight into how things look from the other side (i.e. from the museum perspective) and gained a deeper

understanding of all of the elements that go into an exhibition or acquisition.

No matter what I have done, I have always done it at 150%. I believe in making the most of whatever your situation is at the time, and I have always tried to take advantage of every opportunity in front of me. While in graduate school, I assisted Dawoud with the photography lecture series, which allowed me to spend more time with the various visiting artists that came through, and I also regularly went to openings and lectures around town.

Perhaps because of my gallery and museum experience, I was keenly aware that you could have the best work in the world, but it wouldn't do you any good if nobody saw it. I took every chance I had to show my work to others, particularly at portfolio review events at the Society for Photographic Education conference or at festivals such as Filter Photo Festival in Chicago. I never did the larger review circuit, mostly because the cost made those reviews unattainable to me, but I very much valued the reviews I was able to participate in. Early on, I participated in competitions such as Photolucida's Critical Mass and the Magenta Foundation's Flash Forward, both of which helped me get my work in front of a large number of influential people. Currently, I am focusing more on grants, solo exhibitions, and curated museum exhibitions.

Over time, I have begun to get more significant exhibition opportunities and have built a base of institutional collectors and supporters. Many relationships that began five or even 10 years ago are just now leading to tangible collaborations - you never know where a connection will lead over time. I work hard to stay in touch with everyone who has supported me in any way, big or small, and I am constantly working to contin-

ue getting my work out into the world. From the outside, it sometimes appears that good things just magically happen to certain artists, but it takes a significant amount of work (and a lot of rejection letters along the way) to regularly achieve any amount of success. My biggest goal has always been to find a way to continue making my work, and I am grateful to be working as a full-time artist.

I have certainly had my share of luck so far in my career (and will hopefully have more), but I think hard work, sincerity, and being kind goes a long way. It is so important to build a community and support other artists. Many people have opened doors for me and I try to open doors for others whenever I can. Individual relationships, whether with curators, collectors, or other artists, form the base of my career and are, without a doubt, the most important aspect of any successes I have had.

Your work is poignant and timely. Has that been an asset in finding an audience (and collectors) for the work?

In some ways my work is very contemporary because it engages with issues of identity, gender, and sexuality. However, formally, it is very much in line with traditional portraiture. The subject matter of my work has certainly helped me find an audience, as well as exhibition and lecture opportunities, but I wouldn't say it's an asset for finding collectors.

Portraiture in general is a tough sell, and adding another layer of complication on top of that makes it even more so. I find that many people want to exhibit or look at my work, but it is more difficult to sell it, particularly to individuals. Museums and institutional collections, as well as serious collectors, are the primary audience for my work, and this is something I

am very excited about. I have been fortunate to have my work acquired by several major museums in recent years, and I hope to continue growing this aspect of my career. I find it very exciting to have my work collected, preserved, and exhibited in museums and hope that this increases its visibility and impact.

You said you have focused on museum acquisitions and institutional collections (as opposed to private collectors), because your work is not easy to sell commercially. How have you done that, and how would you advise an artist with challenging content to build the platform necessary to begin to be acquired at that level?

First and foremost, I would advise artists to focus on making strong, interesting work. This is the most important element of a successful career, and without this, all of the networking in the world is meaningless. There will be ups and downs along the way, and the most important thing is to keep making the work and keep moving forward.

I should also clarify that I do sell work to private collectors, but they tend to be serious art collectors as opposed to buyers looking for more decorative work. Collectors and museums often work hand in hand with exhibitions and acquisitions, so I would hesitate to draw too strong of a line between the two.

I have slowly built relationships with museum curators over the past 10 years and am always continuing to do so. If I am traveling in a new city, I'll reach out to the local photography curator (or curators) and ask to meet and show them my work. More often than not, they say yes.

Some museums have open submission policies, including the Museum of Contemporary Photography in Chicago, IL, the George Eastman House in Rochester, NY, and Mass

MoCA in North Adams, MA, just to name a few. I would advise artists to submit their work to those museums and any others who are open to receiving work.

Working with commercial galleries has been an important part of my career and also an important way to connect with museum and institutional collections, as galleries have their own relationships with curators and collectors and can play a significant role in both exhibitions and acquisitions.

I would advise artists to stay true to their work and be patient. Nothing happens overnight, but museum exhibitions and acquisitions, in particular, do not move quickly. Get your work in front of as many people as you can, but also make sure to research the venues you are pursuing. Follow curators who are interested in the kind of work that you make and seek them out specifically whenever you have the opportunity. Be polite, be professional, and don't waste their time. Curators are busy people.

Also - and this is important - don't react negatively to rejection. I have seen so many artists throw a fit if their work doesn't get into a show or if they're not chosen for an award, and this does nothing but assure that you will never get into that show or get that award. If you get a rejection, try to not take it personally and realize that it is not necessarily a reflection of the quality of your work. Perhaps the curators loved it but just couldn't fit it into that particular show. Always be gracious and keep in touch - you never know what opportunities will arise down the road.

Adam Smith

A dam Smith is an artist living and working in Seattle, Washington. Employing photography, painting, and collage, Adam is primarily interested in exploring the tensions that arise from the dichotomy between our connectedness to one another as humans and our simultaneous solitary experience as individuals.

His work has been exhibited nationally at the Newspace Gallery in Portland, Vignettes in Seattle; and internationally at the Getty Gallery in London. Recent publications include Burn Magazine, Elle Men China, Featureshoot and Fraction Magazine.

A few years ago, you were invited to have a one-night pop-up exhibition at a local gallery. Had you had much exhibition experience prior to this, and what were your feelings about this opportunity?

I had had some limited exhibition experience before, but this was my first solo show in a gallery. Leading up to the exhibition, I was feeling a mix of excitement and anxiety. I was

excited because the gallery had a great deal of momentum behind it at the time. It was well-respected within the community with a lot of buzz around it, so I felt like it was a great chance to connect with potential collectors. They had been showing many talented, up-and-coming Seattle-based artists, so I felt like I was in good company. I was also excited to see my project in its entirety framed and on white walls.

This excitement, however, was tempered by expectations that gave rise to an attendant anxiety: Would the work resonate with people? Would they like it? What if they are indifferent? Would it sell?

What were your goals for the exhibition, and how did you set it up so you could meet those goals?

My overarching goal for the exhibition was to start a relationship with people who felt a connection to my work. I also wanted to find that work a home. To do this, I decided to make the work very affordable, but there was a catch. Collectors that were interested in buying a piece could do so at a deep discount, but they would also have to give me something additional in return.

I created a set up where anyone interested in one of the exhibited photos would pay a minimal amount - $35, which covered my cost – plus a barter. Meaning, for a little cash and an offer of a personal service or trade item, they would become a collector of my work.

The exhibit consisted of 10 pieces, 11x14, digital C-print, each in an edition of three. I ended up selling out of two images and sold two other pieces for a total of 8 prints sold. Some of the additional items I received as payment: a tattoo, bottles of wine, tutoring and babysitting for my son, a painting, home

cooked meals, farm fresh egg delivery and so on... What was cool about this was that the bartering process required additional contact and follow up with collectors, and that was an opportunity to deepen my relationship with them.

Turnout was great. There was a steady stream of people over the course of the three-hour event. Typically people move from one event to another, only staying a short while at each, but the people who came to my opening really lingered. I think the concept was so engaging that people wanted to figure out how to participate and were also curious to hear everyone else's barter ideas.

And then like I said before, the barter inherently created a situation where I would interact with my new collectors again. It moved from a typical transactional interaction to one where we each felt more connected and invested, and that connection stemmed from the artwork I created.

Do you feel like this experience created a deeper connection between you, the artwork, and the collector? How so?

Rather than create a deep connection, I'd say the overall experience was a catalyst for connection. At the end of the day, the work has to stand on its own as an authentic expression of how I experience the world. People will either connect with that or they won't. No amount of creative pricing or marketing will fundamentally change that dynamic. What this experience did, however, was give me a reason to follow up with collectors to redeem what they had bartered. These interactions allowed me to learn a bit more about their life, and they, mine. It was an opportunity to extend our relationship beyond a transactional one. Having continued to tend to and nurture these relationships, four years later I am still in

touch with many of the collectors I met through this experience, and several have bought pieces as my work continues to evolve.

CHAPTER THREE

Jason Houston

J ason Houston works at the intersection of social and
environmental issues doing editorial assignments and col-
laborating with NGOs and other cause-driven clients using
photojournalism and ethical reporting to inform on important
issues, illustrate action and solutions, and engage audiences for
positive change.

Recent projects include social, cultural, and environmental
stories on fisheries across the U.S. and throughout the devel-
oping tropics; issues affecting isolated tribes in the Amazon;
deforestation and orangutans in Borneo; wildland fire man-
agement in the western U.S.; watershed conservation in Peru
and Colombia; and cultural preservation and agricultural her-
itage on the Navajo and Hopi reservations in Arizona. Venues
and outlets for his work range from The New York Times,
Pulitzer Center on Crisis Reporting, National Geographic
News, Smithsonian, Orvis, Science Magazine, Businessweek,
and The Nature Conservancy, to Mountainfilm, Harvard, the
New Mexico Museum of Art, and Fovea Gallery.

As a working photographer doing a range of both commercial and editorial work, you made the decision to significantly narrow your focus and specialize. Tell us about that decision.

It was scary, but simple really. Throughout the early 2000's, I was doing everything from magazine stories and studio product shoots to weddings and even some photo editing. I'd already been working professionally for a decade and being a generalist was often a fine business plan. But that was also when digital photography was coming into its own and more and more people were quickly learning to be pretty good photographers. This along with changes in editorial assignments, the internet becoming a huge consumer of imagery, commercial campaigns incorporating social media, etc. fundamentally changed our industry. There's more demand for photography now than ever in history. And more and more people (from pros with DSLRs to average people with their phones) are producing better and better photography. This is raising the visual literacy of the world in general and the potential value of photography specifically. But it also increases competition and potentially lowers the fees we can command. My way of dealing with this was to specialize: I've always worked photojournalistically and been motivated by cause-driven stories, and so for me the focus was on non-profits and others in the purpose driven sector, and issue-driven editorial photojournalism. And specifically, even more narrowly on dynamics at the intersections between social/cultural and environmental issues, usually in the developing tropics.

Here's my rationale: If a client wants the best portrait photographer, they hire someone who just focuses on portraits and pay well. If they need the best war photographer, they hire someone who really knows how to work in that envi-

ronment and pay well. If they can't afford these experts, they usually end up hiring someone who isn't as specialized or experienced or knowledgeable about the subject — and pay them less. A good specialist in any given silo actually competes with fewer other photographers for the available well-paying jobs and can be in constant demand for their earned skills. The only time a generalist gets the work is when there's less money on the table. And the generalist, while maybe in the running for a greater number of (small) jobs, has less specific value for any given job and so ends up competing with a greater number of other photographers who offer the client (generally) more or less the same value.

Over the last 6-8 years, as I have increasingly focused on my weird little narrow niche, I've become an expert in the issues I focus on and know how to conceptualize and manage assignments and commissions that help my clients tell the stories they need to tell. I provide the photography but also help with strategy and execution. My value to my clients has increased, my rates have increased, and I've transitioned successfully to focusing full time on just the kind of work I want to be doing and am best at.

You mentioned fundamental changes in our industry. Everyone knows digital changed things, but can you expand on that from the perspective of how you've designed your career?

Digital changed how photographs get made, but as important for those of us who do it professionally, it changed how photography gets used. There are so many more outlets and so many more people who want photography, but it's also often the case that your clients are no longer 'photo people'. When I started out, most of the people I worked with as a

photographer always worked with photography — photo editors, creative directors, etc. And folks who were not familiar, professionally, with photography really didn't do anything with it. But now everyone is more or less familiar with photography. The world is way more visually literate as a whole — at least in basic ways. I've worked with magazines recently who don't even have photo editors or with creative directors who have no background or experience with photography other than the hundreds or thousands of (sometimes great) images filling their phones and Instagram accounts. Some of my best clients now are not 'photo people'.

The result of all this is that one can't just show up and make your photographs then move on to the next gig. But that's good. We're in an evolving market and we have the opportunity to help shape it. And, more immediately, we have the opportunity to add value to, and thus bill more for, our services. As it always has, it all comes down to making sure that the photography we do has maximum value to the client. The context has just changed. Do they know how to ask for what they want? Do they know how to structure an assignment or organize the commission? Do they understand what goes into making professional photographs? Do they know how to budget for photography? Are they familiar with your delivery methods? Do they know how to mange professional digital workflow for the highest quality? Do they know all what they can do with the images? Do traditional usage rights and licensing schemes work for them? If the answer is no to any of these, it's on us to educate them and provide them with what they need. If you don't, they won't get every bit of value they can out of your work — no matter how good the photographs are — and they'll be less likely to hire you again for the

same rate. But if you do help them get more out of the interaction than they expected, you're not just delivering on the original job, but you're building a relationship where you become a collaborator and not just a contractor. They'll look forward to working with you again and your services will be worth more. For me, the educating is just an investment in developing a healthy, mutually beneficial relationship with your client and helping the industry develop best business practices, but things like strategy and implementation, etc. are all services you can and should charge for.

The ease of creating images has also affected the way people view fine art photography. How can your advice translate to a fine art photographer, in terms of educating potential collectors – especially those who may view themselves as pretty decent photographers – to the value of fine art images?

I don't work in the fine art world, but I am surprised if it is true that collectors devalue photographic art simply because the process is any easier or harder. I also don't believe that just because one might see themselves as a good artist it would devalue the work of other artists — I actually think that might increase the appreciation for others doing good work. So if the ubiquity and ease of photography is changing the perceptions of collectors, it would seem to me the effect comes from their being a lot more work out there to consider (sort of like supply and demand) and/or them being a more visually literate (or at least visually experienced) audience. So maybe if work leans on 'gimmicks' that have to do with the technical process — including printing really big, digital post-production, etc. — is becoming less interesting as those processes become easier to do. In the end, whether it's photojournalism, fine art or

commercial photography or whatever, value will always come down to how well the image expresses the unique vision of the photographer and whether that vision resonates with those looking at the images.

Lori Vrba

ori Vrba is a self-taught artist committed to film and the traditional darkroom. Vrba's imagery is rooted in themes of memory, illusion, loss, and revival. Her assemblage works combine found objects with original photographs that speak to the southern sensibilities of storytelling. Her solo shows have been met with great acclaim both nationally and internationally. Her work is held in permanent as well as private collections throughout the world. She is the co-founder of Pigs Fly Retreats. Vrba is co-curator for the Fox Talbot Museum's 2018 exhibition, "Tribe: American Women of Photography." Her first monograph, published by Daylight, was named one of the top ten photo books of 2015 by American Photo Magazine.

You have had gallery representation in the past, and then you decided to change course. Can you talk about that decision?

Yes. Following the traditional model was important to me for many years and it was a calculated, focused pursuit. I

achieved some level of success within this goal, and had representation with four galleries across the country.

I am grateful for a few remarkable opportunities and experiences. But ultimately I felt the bad outweighed the good. I don't believe the traditional gallery model is as beneficial to artists as it perhaps once was, but everyone is still playing the same game, and the artists are the ones who lose. I have not only carried the full financial weight of exhibitions but then also had to fight to be paid for work that sold. No one will ever be as personally, professionally or financially invested in my life's work as I am, and I would prefer not to split the profit with someone who isn't. We are overdue for a paradigm shift.

Any idea what that paradigm shift could or should look like?

Not that I even pretend to know everything or have all the answers...but I do know that first there has to be respect for the artists. I think collectively that's been lost over the last twenty years. Generally speaking, I would say we are a fairly desperate lot and are easily swayed into taking on burdens that should be shared amongst all who could potentially benefit from exhibition sales. Oh, and contracts... we should demand signed contracts where every task is defined and designated. Everyone does their job? Everyone gets paid.

I actually believe that the lion's share of the movement toward the new order rests on artists' shoulders. We must recognize our own worth and power. Every working artist who wants to exhibit and sell work needs to be asking themselves how best to make that happen. Think CREATIVELY! Do your homework. Commit to being independent. Support your peers. Be supported by your peers. Work your ass off. Make

bank. Invest in yourself. Quit waiting for someone to save you or make you. Do it yourself. Be less desperate. Protect your life's work like a mama bear.

So these are my initial thoughts. Not that it solves every problem or any of them but it's a movement.

Move·ment: a group of people working together to advance their shared political, social, or artistic ideas.

How have you continued to move your career forward outside of the gallery system?

As I sit here considering the question and how best to answer, it occurs to me that I'm not doing anything remarkably different than what I've ever done to move my career forward outside of the gallery system. Even with strong representation I felt wholly responsible for getting my work and my name out into the world. And I think I've always been pretty good at it. That may sound arrogant, but my hustle actually comes more from insecurity than bravado. In my mind, being self-taught and relatively young on the scene has meant I have to work even harder to make it.

So. I invest in myself. I make it a financial priority to attend festivals, portfolio reviews and gatherings with my peers. I collect good, like-minded people and nurture those relationships. These things have proven to be invaluable over the long-term.

I strive to use social media wisely – in a way that feels natural and fun for me while also representing myself and my work well. There have been some phenomenal opportunities that have come my way based solely on my social media presence. I don't ever discount the power of the post!

I exhibit my work consistently. I look for opportunities with museums, photography centers, and university spaces. I am also wide open to the idea of alternative venues and in some ways I have grown to prefer them. The white box is old news.

I sell work however I can. I sell it from my website. I sell it on social media. I sell it in shows. And I have thoroughly enjoyed being paid over these last two years with a sense of pride in my own efforts and independence. Make the work, pimp the work, sell the work. Begin again.

I have been without representation for almost two years now. I don't sit around wishing for it. Or missing it. Or being bitter about what didn't work. I am grateful for a rich experience that informs my present and future creative career. I once heard Sidney Poitier say that the best deterrent to racism is excellence. That statement really left a mark on me. I apply that thinking to my own life and career. Be excellent. That's how you make it. That's how you move forward.

Ethan Rafal

Ethan Rafal is an artist from the Bay area in California who spent twelve years creating an autobiographical project examining the relationship between protracted war and homeland decay. The resulting self-published monograph, *Shock and Awe*, is part journal, part photo essay. Ethan launched the *Shock and Awe* Book Tour as a way to not only sell the book but to also create a community around the subjects the book addresses. Traveling to over 100 venues on two continents over two years, each stop involves a presentation/performance of the book with stories, discussions, bourbon and cast-iron walnut pie.

Why pie?
Ooh! You're good! Tricky one!
The pie happened rather organically. I suppose I was looking at several issues surrounding the book process and, as the tour idea emerged, the pie came with it.
Some background –

I am based in the Bay. The intersection of food and art is really tight here. Hell, we have galleries that do nothing else but nail this. Just sort of in the air here. And then, of course, my friends and I run the Farmstand, a gallery that is built into an honor system farmstand on an organic farm. This project - honor system food commerce - emerged at the end of what people were calling Social Sculpture and now seem more likely to call Social Practice. We used to just call it "doing stuff." This was all the idea of Mickey Murch, a wild renegade fellow that has been ripped off so many times it's insane. And he doesn't care at all -- a real artist. When we were younger, living in Portland, he used to cook gigantic, communal meals in public space with these crazy sculpture mobile kitchen things. Wild stuff.

I was also influenced by my dear friend, Rosanna Nafziger. Her book, The *Lost Art of Real Cooking*, is one way to get a sense of her work. She's a poet, and she really influenced the way I make pie, and why. I stole the cast-iron thing from her.

Of course we are still stuck on Why. For someone outside the culture I participate in, the short answer is "COMMUNI-TY." All caps for emphasis. When I went to bring *Shock and Awe* into the world, things were grim. The United States wasn't looking any better off than when I made the photographs, wrote the stories, and found the materials that constitute the journal. And I'm like, shit, am I really going to just rub salt in everyone's wounds? Can my own community handle this?

Of course this was to say nothing of people who may think I'm a total wacko without ever meeting me, or seeing the book. I have never felt like the United States was, or is, divided in the way that the media claims, and so many people tend to think, but I knew that bringing *Shock and Awe* around the

country was going to ask a lot, particularly from people who may have acute traumas behind our shared history since 2001.

You could call it "a spoonful of sugar." Some have remarked that I make "safe-enough space," a term generally designated for trauma therapy. Others have said that I'm like a grandma, trying to take care of everyone. I have heard that I create a feminine space for dialogues generally overrun by patriarchy, mansplaining, etc, and that simultaneously there is a critique of patriarchy built into *Shock and Awe* -- most of the portraits are, indeed, of men. I really don't know.

I bake Walnut pie. This is a California recipe, long out of fashion. The story I've got is that it was the poor man's pie, back when California was a frontier. It's bitter, it has tannins. Cast-iron. Serious, serious about that crust. Butter, no lard. Pair it with bourbon-and-milk. And about that -- you can now order a *Shock and Awe* at a couple of bars around the US. I'm proud to bring this back in style.

So backing up a bit. You created a book, self-published, about a tough subject. 1000 copies? Most people set up book signings at bookstores and print exhibitions to sell their books. Why did you decide to go a different way? Has it been successful?

True. 1,000 copies -- also true.

I'm not sure about book signings nor print exhibitions. I guess I could have tried that path? It's interesting to think about this in retrospect -- at the time I just did what I thought was possible. I have pondered this a bit, and I guess there is some context.

The tour concept grew out of the DIY stuff floating around the Pacific Northwest. I had a formative moment with K Records in my early 20s, just after coming back from Sudan. I was

publishing pictures in magazines, moonlighting as a photo-journalist I guess. It was a really bad patch, and then I see my pictures in these glossy magazines with diamond ads and shit. It didn't make any sense. And then I go to this K Records show, and there's this frumpy middle-aged post-punk guy selling records from his shitty Toyota trunk. He would just call people and make shows around the Northwest. The audience became performers, the whole nine yards -- an outgrowth from the Beat Happening stuff from the 80s. And of course these recent years I'm in the bay. Some friends up north grew up around all the actual Beat folks. I guess you could say all of this affected what I thought was possible. My friend Alison Pebworth did a tour with paintings and information gathering, and this really seemed rad. I've known for about a decade that I didn't want to be part of the mainstream art world, nor to work for magazines. To say it in art speak, it seemed imperative to build the social container surrounding the art object. I guess it also helped that I had a background with performance and social practice and always wanted to combine all these elements into my total practice. I guess you could say that I've always just wanted to share my work in a way that I could stand behind.

Has it been successful? Good question. At this moment I'm being stiffed by a University in Germany. I'm owed tons by bookstores and Universities around Europe. I'm as broke as I ever was, it's just that now I'm a full-time artist. And I can look at what I've done and feel good about it. And I should mention, too, that I really want people to borrow freely from the tour model. I'm so down to help. Just a small warning that being an artist is no joke - there are very real sacrifices that

affect your whole life - so just call me when you know there's no other choice. ;)

Re Self-Publishing: In case I didn't say it before -- I published the book myself for three reasons. I was working from a 3d object -- I make handmade books, so I wanted to match what I had made. I also wanted fair labor, and I wanted fair-trade materials. I only had one substantive offer to publish *Shock and Awe*. They wanted help with the cost of production, and the whole thing was otherwise just wrong for me – overseas printing, cheap materials, etc. *Shock and Awe* is in many Special Collections libraries -- I am really proud of this. My heart is still in Artist's Books, but I hate the precious edition of 5. I wanted to make a work of art that a middle-class person could afford. I'm proud that *Shock and Awe* has been received and supported by a wide audience.

So is the plan to keep touring until you have sold all 1,000 copies of your book?

The tour timeline is funny. It began connected to the book and to sharing it. Hint: my goal was never sales. I'm just not motivated that way. I'm just a straight-up crazy artist. That said, I had a debt to crush.

The tour began as a way to get the book out, but the book is now getting toward sold-out, and I don't see the tour as so connected to that any longer. I don't know if I'll do another 100 cities, or whatever it's been, but I will perform *Shock and Awe* after the book is sold out (I assume the last copies will be gone before the fall is over). The performance has grown into its own thing. I now deliver this in lecture halls. It's just a distinct piece now. I've always been motivated outside of the book. It's not that *Shock and Awe* is an umbrella, it's just that

the different facets of my total process have their way. And when I see something growing, I nurture it. People have been responding really well to the oral tradition, and I love it. So voila.

Anyway, back to the book. In terms of brass tacks, sales have been good. But as cautionary advice to anyone considering it, I do not recommend printing 1,000 copies of anything. Everyone says it - and it's true! I note that so many photographers don't frequent book fairs. This is a must before making a first book, both for figuring out the numbers and for finding the right way for the project.

Also in the department of cautionary advice, the timeline for this kind of thing is insane. *Shock and Awe* - the First Edition - took three years to bring into the world. I am now dealing with the Special Edition, which is launching next week! Four and a half years after I did the pre-sale. Whoa. I guess my motto might be - "yesterday's news, tomorrow!" But really -- it is a process more suited to slow ideas rather than fleeting experiment. I have been on-tour for huge parts of the last year and a half.

As for what all these years mean in terms of the future -- we shall see. When I'm on tour I get invitations from museums, magazines, all sorts of folks curious and excited. But things tend to quiet down when I'm back in San Francisco. *Shock and Awe* has had a wider following than other projects I have done -- I hope all of this carries forward. But you never know -- some folks interested in the narrative of the breakdown of the United States since 2001, may have little interest in the process and materiality of the images themselves. This is a huge part of what I'm working with in my next project - an Anti-Western of sorts - so we shall see.

My general feeling about support and collectors is that it's just about building community and nurturing it. Be fearless in your support of others. When I hustle for others my success rate is near 50-50. When I hustle for myself, it's like 5% or something. So it's really wise to help other people. If we all helped others - just an hour per week - the whole game would be different. I help make a few shows every year, and I constantly write emails introducing work, etc. I am not sure any of this directly comes back to me, and I do as much as I can anonymously. It just seems to me that we all live and thrive in communities. Anytime I feel like my work is slow or not going as well as it should, I just try to help someone else. My goal is always just to keep the whole thing moving, positive, meaningful.

So your original goals were to build community and sell your book. Both of those things have happened, with the additional benefit of evolving your art practice and this particular project. You hope the audience and network you have created through the tour will support your next project, but at the end of the day, you are living your life and creating your art in exactly the way you want. Win?

I guess for me, yes, something like a win. But I don't want to win alone. My heart is in seeing the system change. I think that for many artists - especially for those that pursue graduate school - photography and books are an intense gamble that rarely pan out. Part of this is beyond the control of the community, but there is much that we can do to create a more solidly middle-class existence.

I note that many younger artists get quiet when this conversation comes up -- art schools still peddle the myth of the 1% artist: a gallery, book deal, collectors, museums that pay,

etc. This myth reflects American society, so it's no big shock. But it's not true, maybe never was. We don't have a functioning system, and we can do better for ourselves. To me, this starts with dismantling our myths.

The first American Gilded Age didn't produce the world's essential art. I don't think this Gilded Age 2.0 will prove any better. The myth of the 1% patron is pervasive. Everyone has heard the old drunk guy at the opening, "artists have always had patrons." This is the same guy that breathes in your ear, "my 5 year-old could have made that painting." It always sounds like one guy, mere ignorance, but this adds up to a dysfunctional system.

It's not a perfect model, but I hope to help build a culture of support for photography - through books - similar to what we have for independent music. Touring in Europe, I noted that my audiences were middle class, and they identified themselves as patrons. In the US, everyone thinks that artists are, or should be, secretly funded by billionaires. My US audience is either rich, or poor.

If we ever have a middle class again, I hope for this to be the base of support for the community. When people buy records they identify as patrons, and keep bands touring -- this is my dream for photography books, and for Art more widely.

The only period when American Art has been essential to the world (mid-late 20th century) is also the time with the widest middle class, most effective taxation of the wealthy, most rigorous public investment, the NEA, etc. It's not just important for the individual artist, it's important for our society, for the enduring meaning of our civilization.

I'm heading back to Norway soon, in part to spend time with artist unions that very effectively lobby the government -

- UKS in particular. Unionizing is a vital MUST for working artists (WAGE has done great work thus far!). In the interim, I call on the community to help change the culture of support -- demand better, identify as the artist, institution, and as the patron. Tour! Host when you can. Dismantle myths, organize, cooperate -- and bake a ton of pie. ;)

David Foster

David Foster is a nature photographer best known for images that convey the essence of his favorite subjects – botanicals and water. He has a special interest in the emerging focus on the healing power of nature and nature-based art/photography.

He exhibits his artwork widely, having been part of over 70 regional, national and international exhibitions – solo, group and juried – in the past 10 years.

In 2014, he collaborated with Julie Hliboki to create a book entitled, *Breathing Light: Accompanying Loss and Grief with Love and Gratitude*. In it, 57 of David's nature photographs accompany Hliboki's poems and prose that convey how love, gratitude, and compassion arise over and over again in the midst of suffering.

His exhibitions, writings and teaching are all part of David's growing interest in and commitment to the healing power of nature-based art and its role in enhancing an array of healing experiences. He currently lives and works in Atlanta, Georgia.

How did you come up with the idea to pitch your nature photos to medical outlets?

I have realized over time that when I am out in nature, I find my emotional and physical aches and pains diminish or go away. I find that when I am photographing in nature, I become fully absorbed in the moment, seeing more deeply the beauty and wonder that is around me. In that experience, my physical and emotional selves experience some form of healing. I have also discovered a parallel experience when I am looking at my favorite nature images and find myself pulled back into that sense of wonder and release.

With these experiences in mind, I have come to see medical environments differently. The vast majority of hospitals and other health settings I visit have walls that are bare or are dotted with non-descript, "invisible" art. Similarly, this is true of most waiting rooms and treatment rooms. Many people who visit these settings are under the stress of illness or worries about what to expect during their visits. I know from my personal experiences in these settings that I would love to have beautiful, engaging nature art to hold my attention while I am waiting (instead of blank walls or anatomy charts). Also, staff who work there are doing so under stressful conditions and experiencing emotional as well as physical fatigue. Given this, these medical environments seem like the perfect venues for uplifting, nature-based art.

At the same time I was having these personal insights, I discovered there is a growing field of scientific study pertaining to "healing environments" and the ideas of evidence-based design for both architecture and interior design in health settings. Among the findings from this work is that the presence

of nature in health care settings is a key part of creating healing environments. Since having actual nature is most often impractical, nature-based art can be a significant substitute.

There also seemed to be a growing presence of "healing power of art" posting on the internet at that time. One that got my attention was an international exhibit competition called "Celebrating the Healing Power of Art" by Manhattan Arts International (MAI). In 2014, I entered and was chosen as one of the 50 featured artists. In addition, I was selected for their PC Turczyn "Art that Promotes the Healing Process" Award and was featured on Pam Turczyn's blog site and the MAI website. This experience elevated my personal investment in pursuing this path, with the affirmation from national experts that my work was a strong fit for this purpose.

I also realized that this feedback was consistent with what I had heard in viewers' responses to my work. Over the years, I had received written comments from my exhibit visitors that suggested they were having some of the same experiences from engaging with the images that I was. One wrote, "Breathtaking, what a joy. ... What a wondrous sense of beauty and delight – I am renewed, refreshed just gazing at your photos."

In just one more example of the universe trying to tell me something, Julie Hliboki approached me about collaborating on her book, *Breathing Light: Accompanying Loss and Grief with Love and Gratitude*. Her selected writings are paired with 57 of my nature photographs. The book was published in the fall of 2014, on the heels of my experience with MAI. The book has gotten a great response, and many people have commented about the power of the images to evoke a sense of calm and well-being.

Finally, as I have floated my emerging ideas of getting my work placed in an array of health and mental health settings – hospitals, clinics, offices – I have received consistent affirmation that that is a good idea. And so, I now have increased focus on pursuing this quest.

What steps have you taken to market your work to medical facilities and what longer-term goals do you have about connecting your work to healing environments?
I have pursued opportunities for exhibits in hospitals that have gallery space for rotating exhibits. I had one exhibition at Wake Forest Baptist Medical Center in Winston-Salem, North Carolina, which ran for three months. I have another three-month show scheduled at University of Michigan Health System's Taubman Center Gallery in Ann Arbor, Michigan where over 30 images will be exhibited. That show will be followed by a similar exhibit at Cooley Dickinson Hospital in Northampton, Massachusetts. I am actively exploring similar venues for future exhibition opportunities.

My investigations suggest that the purchasing of artwork by hospitals, medical centers and other large health settings is typically done through art consultants, interior design agencies, or the interior design departments within architecture firms. I have begun to reach out to a few of these types of firms, but my primary focus so far has been scheduling exhibitions. I am, however, beginning to shift my attention to connecting with these resources.

I have also initiated conversations with some of my personal health care providers and with friends in the field. As yet, these have not yielded direct sales, but I have gotten positive feedback and have been encouraged to pursue it further.

I am also working on some additional components of branding myself as a photographer committed to enhancing healing environments with art. I created a new presentation titled, The Healing Power of Nature Photography. I have marketed it to area photography groups and have booked several lectures to date. I also have two upcoming photo essay features in On Your Doorstep, a digital magazine "using art to inspire the protection of nature". Finally, I have become a Contributing Photographer for the Foundation for Photo/Art in Hospitals based in Florence, Italy. This nonprofit organization uses the work of an international group of photographers to provide healing images to enhance the environments of hospitals all over the world, from Afghanistan to Zambia. I am enthusiastic about this small but concrete opportunity to share my work in health care settings that would otherwise be without suitable art on their walls.

Do you have any advice for other photographers who are trying to find creative outlets for their work?

If you have no experience exhibiting your work but you have a body of work that you think is ready to share, start small, local, and simple. Keep an eye out in your community for venues where you see interesting artwork on display that is nicely presented, well lit, etc. Find out who is in charge of decisions about exhibiting and ask them what you need to do to have your work considered for an exhibit.

A clean, straightforward website with a carefully screened collection of images is helpful in demonstrating your body of work to those who make these decisions. A simple photo-oriented bio is also helpful to introduce yourself and your work.

As your body of work becomes larger and more refined, then you can begin to give more careful thought to the types of venues where you would like to show your work. You may want to consider who your ideal target audience is and what venues they frequent.

In terms of marketing materials, there are several online companies that create business cards and other printed materials (notecards, postcards, etc.) with photographic images. Many allow you to have a different image on each card. This means your business cards, or other printed products, become an easily portable portfolio to share with interested folks on the spur of the moment. The cards give the viewer a feel for your work and can be a conversation starter that leads to opportunities. As an example, I was traveling through North Carolina and stopped to check out a community arts center I noticed. While there, I explored their lovely gallery. I was able to speak with the gallery manager and showed her a dozen or so of my assorted photographic business cards. She offered me an exhibit opportunity on the spot. Thirty-five of my images hung in their gallery in January-February of 2015. Through this exhibit I sold three prints, along with numerous books and notecards.

One barrier I have been working to overcome is my internal resistance to self-promotion. With the help of several key people, I have begun to reframe my thinking to offering viewers a gift. The process of putting my work out into the world gives those who see it the possibility of a meaningful experience. Out of that, some may choose to make a long-term connection by buying a print for their walls, but many people will gain some small measure of enjoyment, comfort, or respite in

those moments of connection. And, one never knows when that experience may lead to some future decision to buy work.

Lissa Rivera

Lissa Rivera is a photographer based in Brooklyn, NY whose work has been exhibited internationally. She grew up near Rochester, New York, home of Eastman Kodak, where as a child she was exposed to the treasures at the Eastman Museum. After receiving her MFA from The School of Visual Arts, Rivera worked professionally in collections, including the Museum of the City of New York, where she became fascinated with the social history of photography and the evolution of identity in relationship to photographic technologies. *Beautiful Boy*, Rivera's latest project, takes her interest in photography's connection with identity to a personal level, focusing on her domestic partner, BJ, as muse.

Rivera has been featured in several publications, including "25 Under 25 Up-and-Coming American Photographers" (PowerHouse Books), curated by Silvia Plachy. She was chosen as a "Woman to Watch" for the biennial exhibition at the National Museum of Woman in Arts. In 2016 Rivera received the The Peter Urban Legacy Award in the Griffin Museum Juried Show and was also a recipient of Feature Shoot's

Emerging Photography Award. Rivera is represented by ClampArt, New York.

You are not new to fine art photography. You have created several bodies of work and have had exhibitions and other recognitions. But Beautiful Boy *has taken things to a new level for you. What do you credit this shift to? Is it the concept or the way you have navigated its release to the world or something else altogether?*

My past success came from a chain of opportunities stemming from initial recognitions as well as the guidance of a supportive community. I had worked very hard at my craft and many people believed in the work. Public recognition began in my early twenties. I sensed the power of what could form in terms of my identity as an artist and wanted to be sure it was truly my voice. I believed in myself enough to take the risk of stepping away for a while to experiment with work that I did not intend to promote. It was hard to live with that decision. I feared that I let my supporters down. When I felt ready to seek visibility again, I had a clear strategy and a strong belief in my voice.

I still have a long way to go to establish my work, but I feel very inspired by all that I absorbed from years of study and experimentation. An integral strategy was to rebuild a community of supporters. The strength it took to reorganize my life felt like a great risk. Investing in the promotion of the work was a financial risk. With *Beautiful Boy*, BJ and I made very intimate work; we were both taking a risk by exposing a very personal side of ourselves. When you are taking these chances, you begin to feel more compelled to make it all count. This inspired the drive to push the work. I realized whatever I thought I gave up in the past was nothing in comparison to

my future potential. Also, I must say there are many more venues in which to promote work from when I started!

It seems like so many artists today are rushing to produce and promote and produce more again, without taking time to let the work simmer and without establishing clear goals and strategies to move forward. You say you took a step back to regroup, and in doing so, you have found a project that seems to come from an intensely personal but grounded place. Do you think most artists would benefit in the same way from shifting their focus and resetting their intention?

I think artists should be wary of creating projects based on perceived external pressure. If it feels right to produce and promote often, then make that part of a conceptual practice. If you are doing it to keep up with others, you risk creating work that is superficial. Ranier Werner Fassbinder completed forty feature-length films in 15 years. It was part of his drive as an artist to make varied work at a staggering rate. Cindy Sherman has been taking self-portraits for over forty years. This work is equally valuable. What matters is that what is made comes from an authentic investigation. Try not to compare yourself to others or follow a formula that does not suit your vision.

When you are talking about an "authentic investigation", does that also address the importance of making the work you want to make instead of what you (or others) think you should make?

Artists can get caught up in what is showing in the moment and be susceptible to mimicking the aesthetic styles that are predominant in galleries that season. It is a very legitimate desire to want to fit into the dominant trends, but by the time

you complete the work, it might look like a slightly less fresh version of what was popular the year before. I think that it is more fruitful to look back at the things you have always been interested in, even going as far back as childhood. It could be a movie you loved and watched obsessively. It could be the way the light fell in your grandmother's living room. It could be something completely uncool, even something you were teased about. Chances are there is something about those original impulses that could be a driving force for your work today. If you investigate your subject thoroughly enough, and with thoughtfulness behind your technique, it will be hard for critics to dispute its validity, because it will have come from a place of passion.

How important is the circle of people and influences you surround yourself with in creating meaningful, authentic work?

It is important to be around people who are producing work and pushing themselves. Chances are they are happier, if perhaps busier. Stay away from people who tend to consume a lot of art and then complain about how conditions are never perfect enough for them to produce their own. Beware of people who are critical of others' achievements instead of inspired by them. Stay away from people who make you feel like you don't fit in. Strive to be a nurturing friend and look for the people who nurture you.

Finally, while it is important to focus on what you want to do, and when and how you want to do it, the reality is, most artists have to balance creating with a day job. Do you have any advice for artists looking to be productive artistically while also working to pay the bills?

Take any window of opportunity you can to create work. I was partially laid off once and only working three days a week, so I decided to completely focus on art on those free days. Now that I work on a more full-time basis, I get up early and stay up late after my day job, and accomplish something every weekend. My vacations are working 'create-cations.' Even when visiting family, I will see if there is a way that I can link up an artistic excursion along the way. Most of the books I read and movies I watch are direct research for my current projects. Of course there's nothing wrong with treating yourself occasionally, but I generally don't spend money on, say, going out to eat at expensive restaurants. I get cheap everything and spend all my money on art. My clothes are not the most up-to-date, and I have not had a decent haircut in years, but my art looks as good as it possibly can, and nothing feels better than that. Nothing feels better than knowing you tried your hardest on your accomplishments.

Documentum

Documentum, co-founded by William Boling (interviewed below), Dawn Kim, and Stephen Shore, is a guest-curated periodical archiving and examining the cultural ephemera of our time. The images in the limited-edition newsprint publication are culled from an international selection of artists making work on Instagram.

What was the impetus behind creating a publication focused on Instagram?

First, my personal work and my interest in publishing has been grounded in an excitement for picture archives that if thoughtfully curated and edited become a kind of vessel or ark for creating and carrying ideas outward and forward through time. Second, I've loved the periodicity of publications that come in installments and for me the newspaper is the greatest example of that ever invented. As newspapers have collapsed over the past decade or so I've become increasingly enamored with the look and feel of ink on pulp. The landscape and topography of a broadsheet is very elegant to me and I wanted to

do something with that form. Third, I've been fascinated by how the meaning of photos -- its sémiologie seems to shift with the prolixity that is driven by digital processes and the web - especially social media.

I'd been searching for the right content and direction of Documentum -- I already had the name and the idea that it would archive periodically subjects through images that were powerful and in someway at risk of being lost. Then speaking to my friend Stephen Shore one day about our fun and love of Instagram picture sharing it dawned on me that this was an ephemeral subject that was in many respects over looked.

We began to discuss it seriously over a period of a few weeks and the idea was born.

Overlooked in what sense?

I wasn't finding any publications taking the work seriously even though strong, interesting work was being shown there by Stephen Shore, Teju Cole, Tanya Marcuse and many others. The mass 'social media' aspect of it seemed to allow this work to be "hiding" in plain sight.

How does a printed publication of an online platform reframe the imagery and in what ways (if any) does it benefit the participating photographers?

As an image passes from any medium to another, there is a natural shift in aesthetic valence, meaning, and opportunities for appreciation and "absorption". A Kodachrome slide represented as a framed cibachrome print will always strike a different register and provide a different experience. "Screen candy" like I enjoy on Instagram is like M&Ms you gobble quickly a handful at a time. The same image shifted to ink on paper

slows down -- bears a little more scrutiny -- is perhaps savored more.

I think most photographers enjoy seeing their work in print alongside other work that's beautiful and interesting. It's less ephemeral and perhaps finds new audiences. And it's fun to be part of a cohort of folks who are traveling together in this unique vessel.

Is Documentum an evolving platform?

The spirit behind Documentum is one of open inquiry, curiosity and fun. We chose Instagram as the first realm to play with and document because, like most forms of online expression, it is relatively ephemeral and prone to lapsing or in many cases 'disappearing'. We reckon in some form or other the old broadsheet forms will hang around in collections here and there. They are more likely in a way to be here a few centuries from now than the IG posts themselves. For future volumes of Dcoumentum, we are looking to move away from social media and will look to other ways that we take and share documents that seems in need of a vessel for now and the future.

Zines

A zine (abbreviation of magazine or fanzine) is a small circulation publication, often self-published and reproduced via photocopier. They are becoming more and more popular in photography and are an accessible and affordable way to share work. The three photographers featured in the following interview, Rachael Banks, Nathan Pearce and Jordan Swartz, all use zines as a primary way to share their photographic projects.

Can you give us a little background/history of zine culture - how and why zines became a popular way to share content and where you think the trend is heading?

JORDAN: From personal experience/ knowledge/ research, zines first gained traction in punk culture. While existing previously in art and literary circles, punk culture brought it into a larger mass production and allowed for people to spread/ share ideas. Production was cheap (often being able to be stolen) and easy to give to others. Photography and related arts saw a resurgence in zines in the early 2000's again for the

reasons of cheap production and ease of sharing. While book publishers often require large sums of money to print with, as well as larger bodies of work requiring more time and ultimately again more money, zines allow artists to get smaller amounts of information into the world and circumvent the antiquated methods of big name publishers.

Where the culture is heading is interesting because a sort of beautiful part of zines are that the makers/ publishers/ printers are often impermanent, and the ones that do stick around usually move on to larger production trends of hardcover books and larger projects. In turn, this leads to a continuing batch of new blood and ideas and content.

Do you create different work for zine projects than you put out into the world as your ongoing fine art projects? And/or do you use the zine as a way to "test" new images?

NATHAN: Sometimes a zine can be a sort of sketchbook for me. Perhaps for a project I am unsure of or a project I really like but am unsure of the final direction that it will go in. I can then experiment with an edit and see how it goes.

For instance, the work I used for my split zine with Rachael, (*All Night Long, Volume 10*), was from a project that wasn't complete. I had the general idea and had made a lot of work for it including rephotographing some family photos, but I couldn't make it feel like a complete project. I had no desire to show it online or exhibit it, but I experimented with an edit and made a split zine. I'm not sure it would have been interesting anywhere else, but I think it was in an appropriate place as half of a split zine. It also helped that the project was about family and place, and that went well with Rachael's work.

In projects that are more fully formed and well defined, I may use work that didn't quite make the final edit but I still like alongside pictures that are more central to the project. In this way a zine can still be unique even if I am going to use the work and re-edit it for a book later. For me, zines are the perfect place to experiment.

RACHAEL: I've never considered making work strictly just for zines. Usually what ends up happening is that I have a smaller selection of images or stand alone images that I am excited about but they don't necessarily fit in with the rest of my work. For my ongoing series *Between Home and Here*, I always end up having a lot of images that I consider outtakes. It's not that they are bad images but they might not fit in with my larger series of work in terms of theme or they look too repetitive next to an image that fits the series better.

I definitely also utilize zines as a way to put my work out in the world and see how people react to images, without going completely broke. In the past, it hasn't been uncommon for me to use images from a series in both a fine art and DIY zine context. It's really important to me that my art is accessible and affordable for everyone. I don't think my work only has to or needs to function in a "higher" fine art community. The work I make is about family and home. We all have a family and/or home in some way, so I don't see why my work can't be available to anyone.

JORDAN: Zines are and have long been a part of my working process, because I don't make work in the traditional body sense. I'm just always photographing, and if the photos work together, then they go together. Zines allow me to be democratic about my editorial process and have old and new images

share space and be given equal opportunity. Text is also a large part of my work and works great in the pages of a zine.

How large is the zine market?

RACHAEL: The zine market is huge! I have no idea how many are possibly being made, but I see them everywhere, and I think even more zines are being put out than before now that self-publishing is a rising trend among artists . Around September of 2015, I attended the *Dallas Zine Party* (Founder: Randy Guthmiller) and experienced it as a really great opportunity to meet new artists from and around the Dallas (but also Houston and maybe Austin) area. This was a really valuable experience for me, because in my time living in Texas, I found that when I'm not teaching or making my own work in a different state that my knowledge of Dallas artists is a little more limited than I would like for it to be. The zine party was a great resource for me in terms of expanding my knowledge and appreciation for local artists.

JORDAN: I have no idea how many zines are produced every year, but I'd say in the millions. It's a huge part of our culture now and has also very much spread to mainstream, where fashion magazines will now include smaller editorials in a stand-alone zine that's placed inside the magazine.

NATHAN: There are thousand of zine makers out there, and lots of zine fests are popping up. The crowd of photo zine makers (and buyers, sellers, etc.) is much smaller. I have attended several zine fests in the last few years, and it's pretty common for there to only be 2-3 people selling photo zines out of the hundreds of other zines. They are gaining traction though.

I think a lot of people who aren't initially familiar with more traditional zine culture come to be interested in making and consuming photo zines through their interest in photobooks. Because of that, I think there are more photo zines at art and photobook fairs and photobook stores than places that specialize in zines. There are exceptions though like the *8-ball Zine Fair* where you are likely to find lots of photo stuff. Despite photo zines being just a small fraction of both zine and photobook scenes, I find both of those crowds to be full of very positive people so the reception for photo zine releases is usually great.

Through those crowds I have found a lot of people who buy zines we put out through Same Coin Press. Some are photographers but many more aren't. I think the fact that they are affordable plays a big part in their popularity. Not only because it's a very small financial commitment to pick one up, but also because people don't feel precious about them after buying them. I'm sure lots of folks collect them and place them next to their signed first edition photobooks, but there seems to be an equal amount who buy them and leave them on the back of their toilet in their crappy apartment. I'm sure there are lots of people who fall in between those two as well. For some people I really think it's some of the first art they have purchased. Folks that either aren't able to buy a print for hundreds of dollars or those who can afford it but have not yet made that commitment can own the work of a photographer they love for $10 or less. What they are getting is something really cool, and because it is likely made in a very small print run it's instantly collectible. It's like gateway art collecting I suppose. People are building low-rent photography collections. I know I am.

How do people get their zines out there?

JORDAN: I think a lot of getting your zine out there is sort of knowing where you see yourself. The first thing I say to people when they ask where their zine should go is, "Where do you get your zines from? How do you find out about new work?" Depending on how many you have made or the preciousness of your own zine, sell them at record stores, leave them on the bus, send them to photographers or other artists whose work you enjoy. I used to slip my zines inside photobooks or novels that I was a fan of so someone who also enjoys that work may find mine.

RACHAEL: In terms of how zines get out in the world, people do a wide mix of things. Personally, I get my own zines distributed through self-promotion and social media. I will also sometimes send free zines to editors/artists/friends who I specifically want to see my work. When I was first introduced to zines, it was when I was a teenager at punk shows and at independent book stores/community centers.

Conclusion

Most artists dream of a fairy godmother who magically swoops in and handles all of the unpleasant and time-consuming tasks associated with being an artist. A gallerist seems like a real-life version of this fairy godmother, and so many artists set their sights on gallery representation. While this is a noble goal, it is not achievable for the majority of working artists. The number of artists interested in working with a gallery are far greater than the number of galleries out there. But even so, you are the best person to advocate for your work and your career. You are the person to whom it matters the most, and you will work harder for yourself than anyone else will work for you.

The examples in this book are meant to get you thinking about your own work and whom it is most likely to appeal to. There are so many ways to insert yourself into the art market,

and if you are not finding success through the traditional avenues, clear a new path. Or create a new market.

Make your work, and then find the people who want to love it. You have a gift to share, so go make a love connection. Or many.

ABOUT THE AUTHOR

Jennifer Yoffy Schwartz is a publisher, photographer, and arts advocate based in Atlanta, Georgia. She is the founder/publisher of Yoffy Press, an independent publisher dedicated to pushing the boundaries of photobook publishing. She is also the creator/director of Crusade for Art, a non-profit organization focused on cultivating demand for art, specifically fine art photography. Jennifer owned a fine art photography gallery in Atlanta (Jennifer Schwartz Gallery) for five years, showcasing the work of emerging photographers. She also created the online project, The Ten, and was the co-creator of Flash Powder Projects. In the spring of 2013, she traveled around the country in a 1977 VW bus, engaging audiences with photography. Her book, *Crusade For Your Art: Best Practices for Fine Art Photographers* was published in March 2014.

CPSIA information can be obtained
at www.ICGtesting.com
Printed in the USA
LVHW051113120221
679116LV00005B/1163